COOL YOUR JETS!

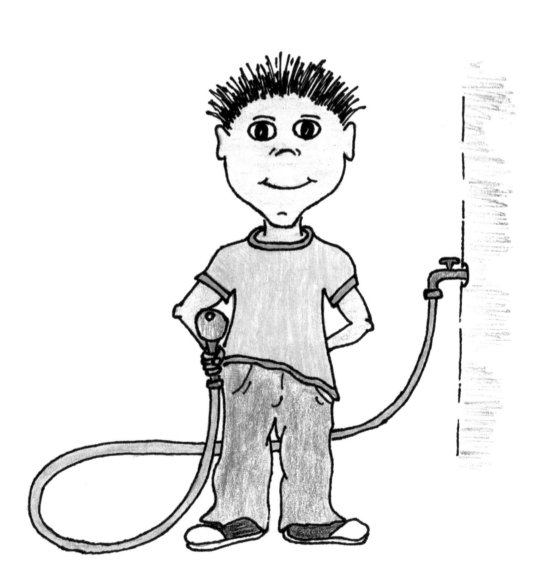

Cool Your Jets!!!

By Mark A. Johnson

Pictures By Richard D. Hamberger
Edited By Melinda G. Johnson

To all children—Anger is a feeling that is normal, and it is a feeling that everyone experiences. Anger is an emotion that we can control if we want to. Life will be so much more fun. You can do it!!!
MJ

To Papa and Grandma Johnson—Thanks for teaching us to Cool our Jets!!!

Print information available on the last page.

Rev. date: 06/19/2019

To order additional copies of this book, contact:
Xlibris
1-888-795-4274
www.Xlibris.com
Orders@Xlibris.com

Hello my name is
Tex . . .

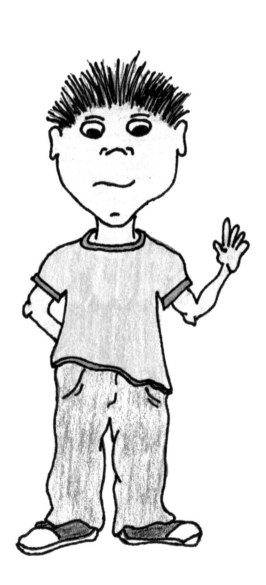

Today is my birthday !!

Oh Boy!!!!!!

Oh Boy!!!!!

I can't wait to play with Michele, Jerry, and Troy.

It's going to be a blast, so cool, so neat –

my stomach is getting full just thinking about all the food I'm going to eat.

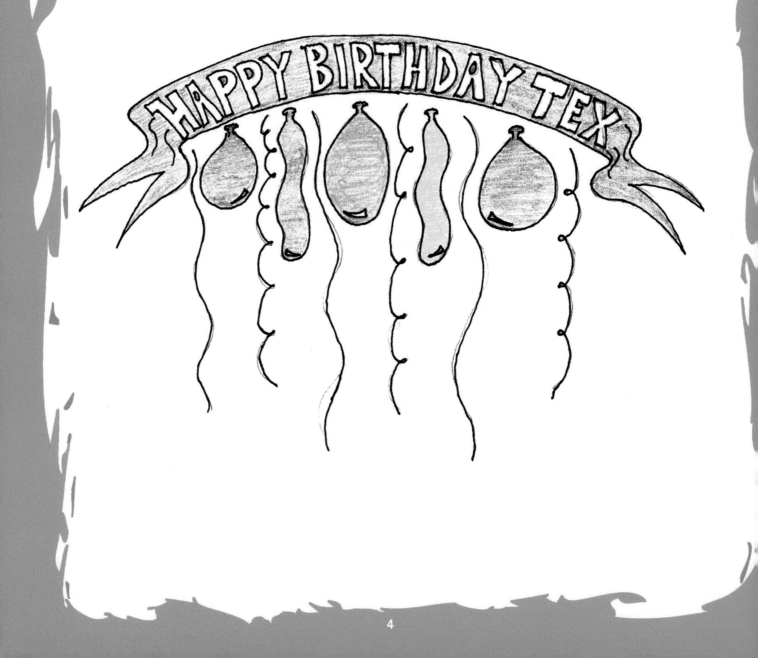

I want a chocolate, chocolate, chocolate, deluxe slamoriffic, cake . . .
The one my mother can so easily bake.
It will have icing and filling and more chocolate on top.
I want to eat all day without Dad saying STOP!!!

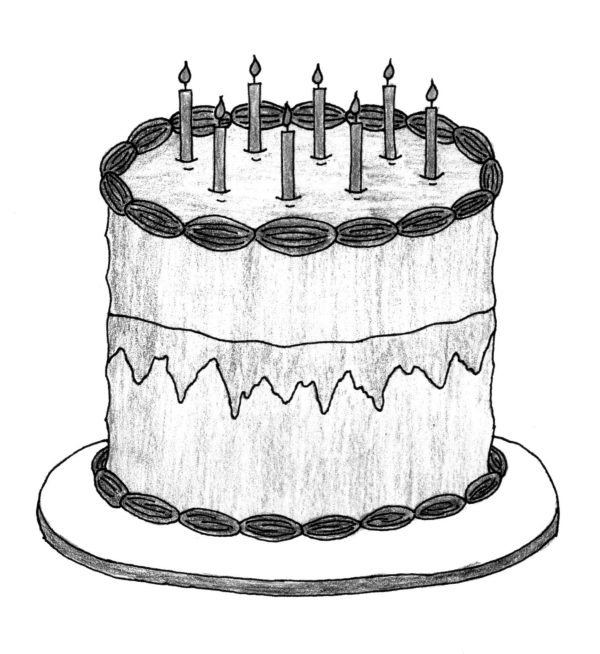

My friends are starting to show up with boxes and bags,
tied with ribbons and string.
There are so many treasures, I feel like a king.
The presents are big and little, short and fat,
wrapped in stripes, polka dots, and one resembling a big furry cat.

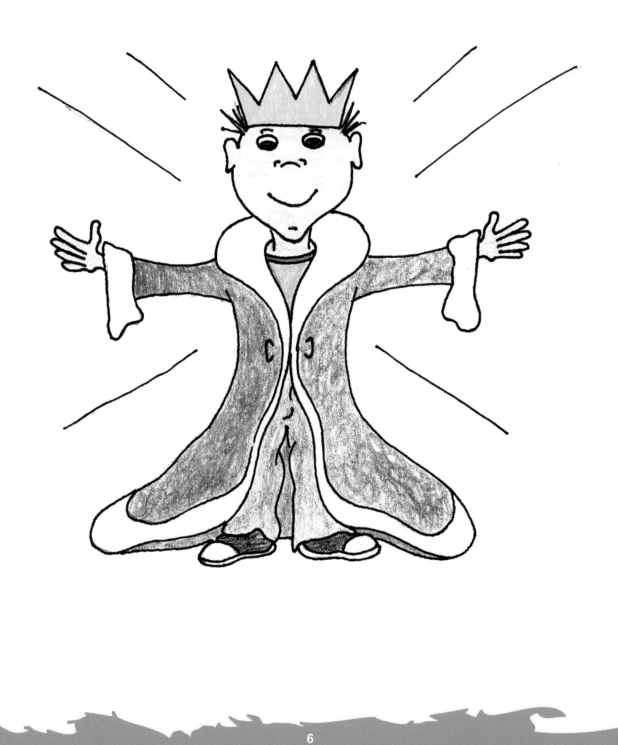

One final guest steps out of his car
walking briskly towards the door from a far.
His present has definitely caught my eye,
a divine curiosity I cannot deny.

Wait . . .

A blinding light focuses on the treasure of this day.
I wasn't that fond of Harold, but now he could stay.

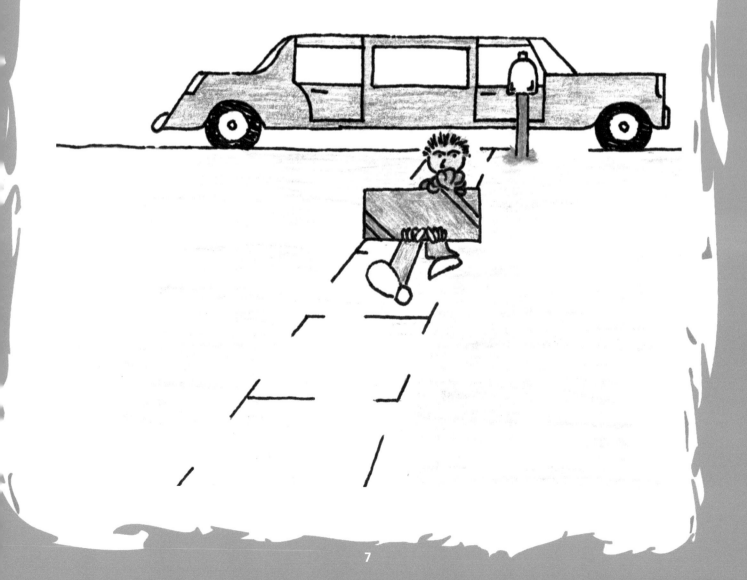

I grabbed the present from Harold, ripped and pulled with all my might,
but the box wasn't opening; I was losing the fight!
Harold laughed and laughed, chuckled and gagged to my distress . . .
He had used 102 rolls of tape so I wouldn't be able to guess.

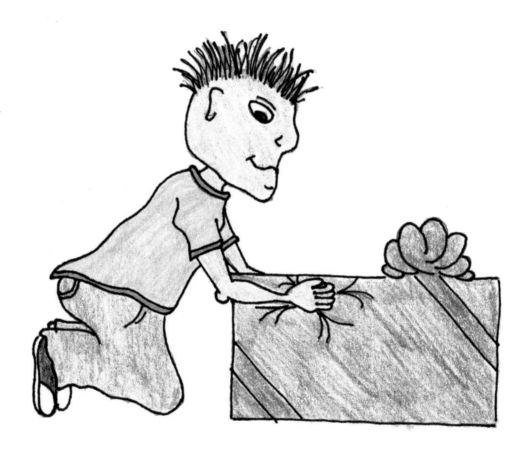

My mom, my mommy, the woman wielding the cutter,
became a hero that instant and not just a mother.
She opened the box with speed and precision,
cutting left and right with no indecision.

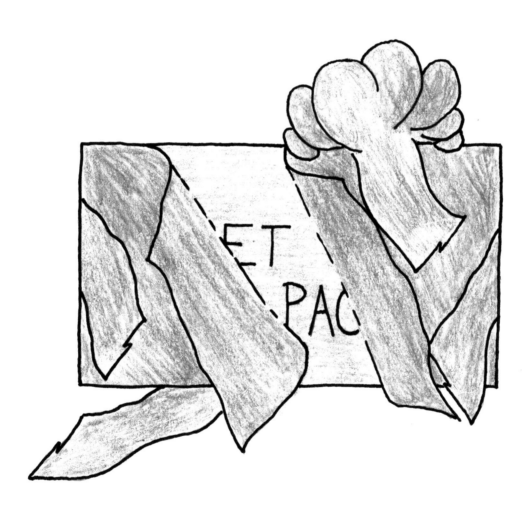

Finally the box was open, and it was time to look inside.

What was the treasure Harold so desperately tried to hide?

I reached inside the box and felt metal on its back.

Pulling quickly, I retrieved it . . . oh my . . . it cant be . . . it's a

Jet Pack!!!!!!!!

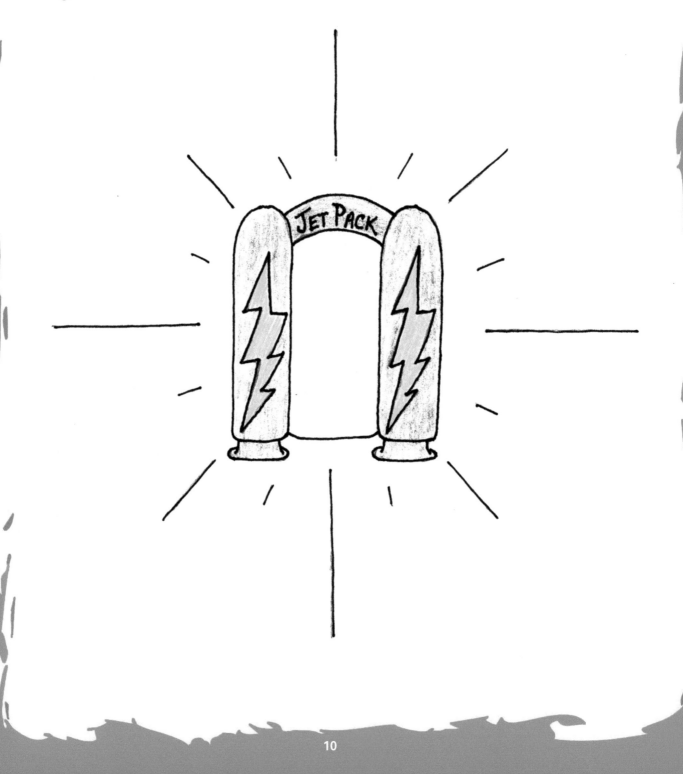

"Put it on me. Put it on!" I shouted to the crowd.
I was in a hurry, and dillydallying would not be allowed.
I lifted my shoulder and inserted my arm into the strap;
a couple more hook ups and I'd be ready in a snap.

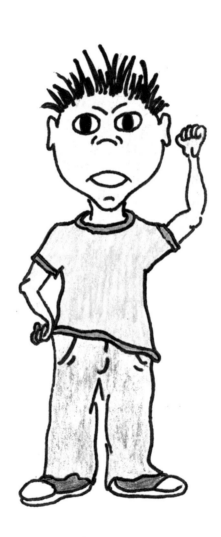

"Wait," Harold screamed as he jumped on the chair.
"You must know a secret before you head to the air.
The jet pack is magic, the directions are clear.
You see, the jets read your emotions, it wont let you steer."

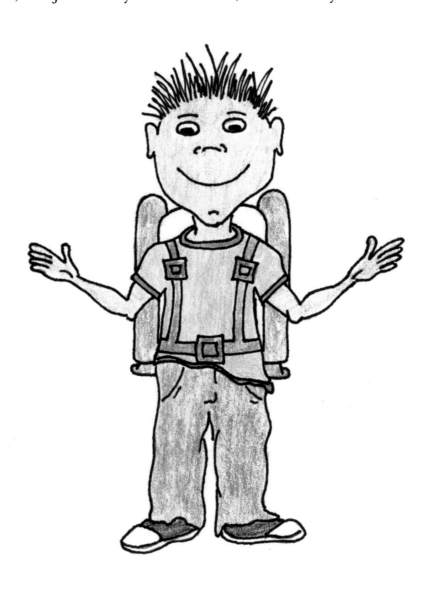

"It's easy to control if you don't get mad.

When you lose your cool though, the results will be bad.

Here are some tips that will help keep your jets cool.

All journeys can be great if you have the right tools.

You can go anywhere: Disney, Paris, or Jamaica.

Just remain relaxed and the jet pack will take ya.

All you do is think about where you want to be,

and the jets take over, getting you there magically.

Caution: The jet pack gets confused when you're angry and red;

it will go hay wire forgetting what you said."

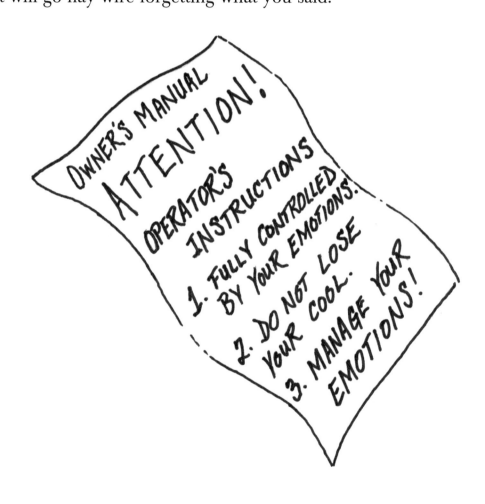

"Sit down. You just don't want me to play with my new toy.
How dare you say such nonsense and ruin my joy!!"
Tex didn't notice it, but he was stomping on the floor,
and his veins were bulging out as he walked towards the door.

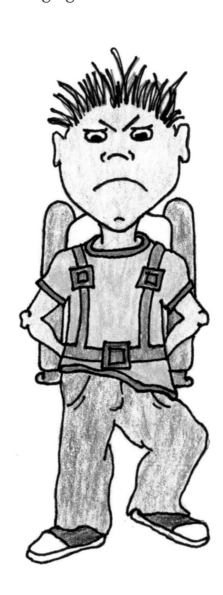

A rumbling sound overtook the room.

The jet pack came alive, and it started to zoom.

Tex couldn't control his temper one little bit,

so the jets became frantic just like his fit.

Up in the air, a crash through the roof, and Tex was flying.

He didn't have control; we heard him screaming and crying.

Tex kept on going, higher and higher.
We couldn't see his face anymore – just the jet pack's fire.
Smaller, smaller, and smaller, he zoomed out of sight,
continuing to scream as he flew through the night.

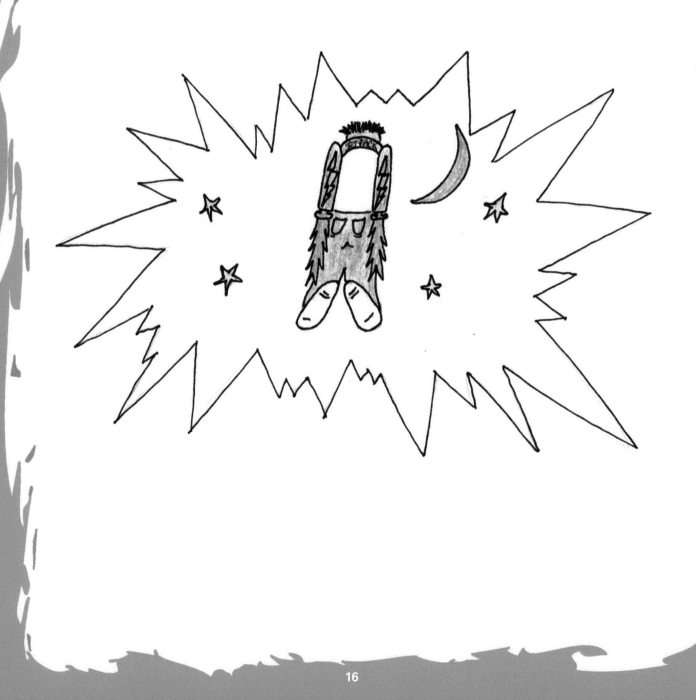

"Make it stop. Make it stop soon.
I don't believe my eyes – there is the moon!
How will I, how will I find my house
when the earth is now the size of a mouse?"

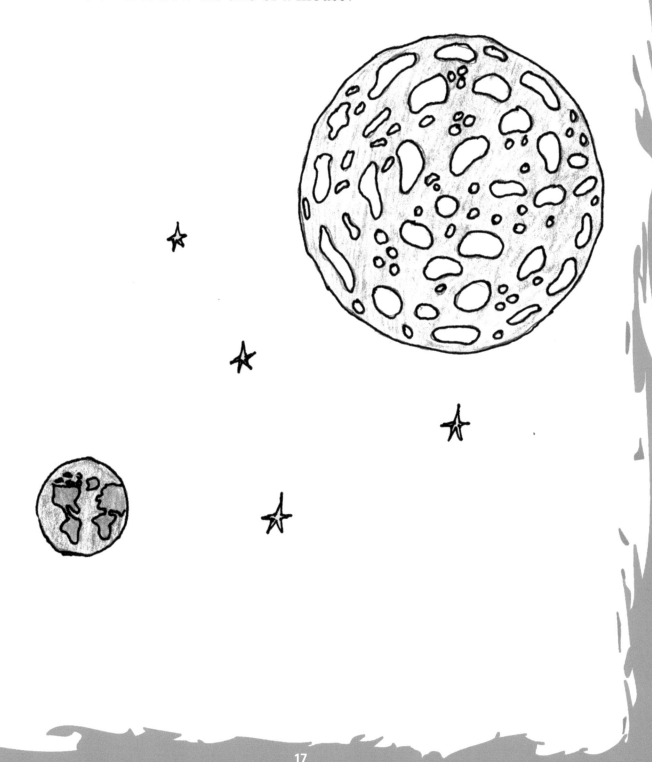

"A lie, a lie, is all I can say.
There is no milk in the Milky Way.
Saturn, Jupiter, and Pluto I have gone past-
How much longer will this jet ride last?"

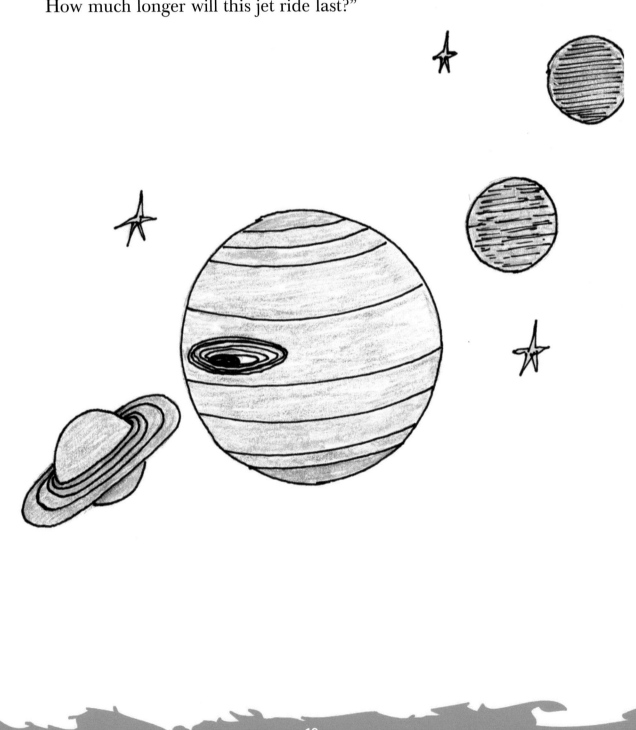

"Land is ahead, just within sight.
I'm trying to slow down with all of my might.
This is frightening; the land seems to come faster and faster.
I hope I don't crash . . . that would be a disaster."

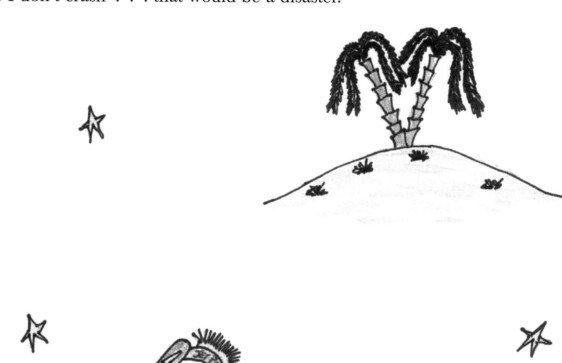

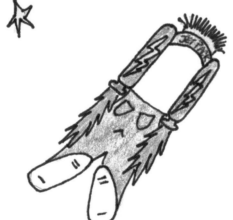

"I've landed. I'm alive, what a relief.
I'm still a little scared about what lies beneath.
My foot, my foot has touched sand.
I hope there are no scary monsters in this land."

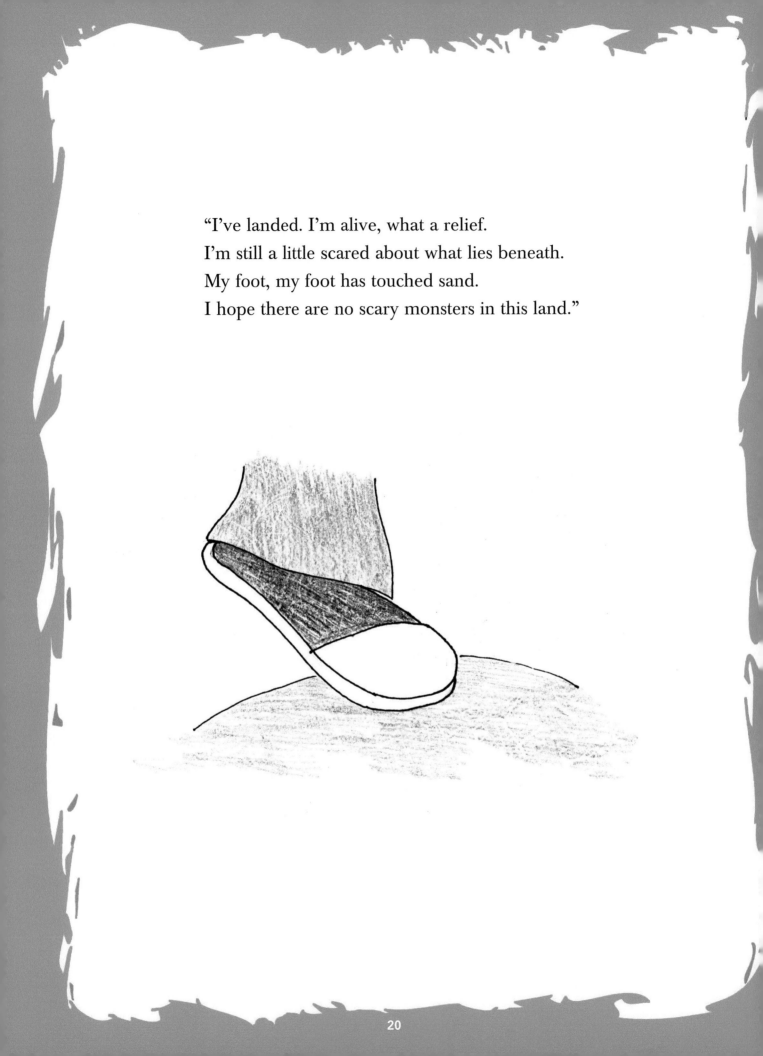

"Hello mister. Welcome to planet Serene.
You're the first human I have ever seen."
Tex was shocked; he couldn't believe his eyes.
If it wasn't an alien, it was one great disguise!

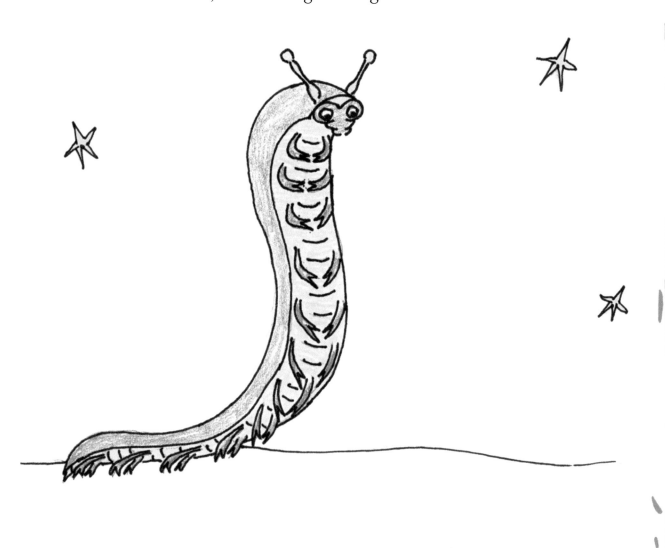

"Hello. My name is Maroy. I'm glad we get to meet,"
she said, offering a greeting to Tex with one of her left feet.
"Hello. My name is Tex. I'm really lost and sad.
My jet pack took off when I got mad."

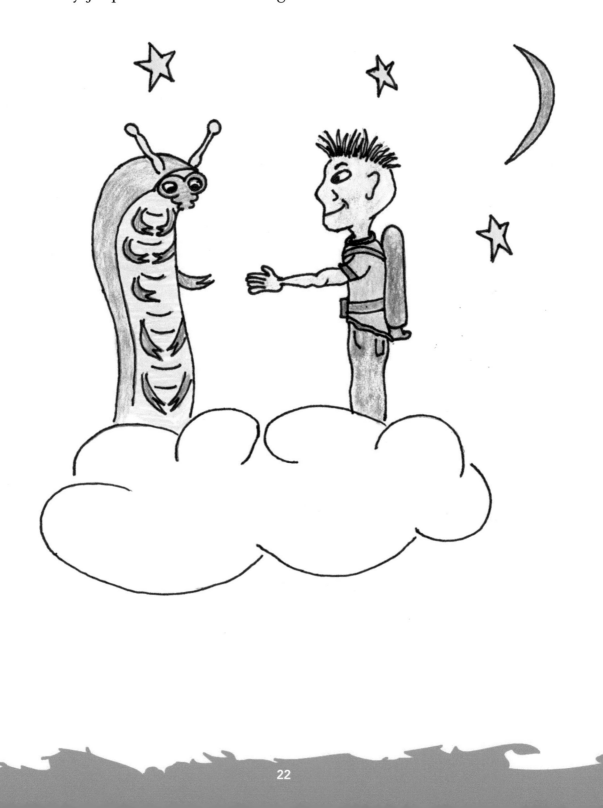

"Now I'm stuck here forever. What else can I try?
I have a problem with anger, so my jet pack won't fly.
If I could cool my jets, I would be just fine,
but I lack the ideas to keep me in line."

Maroy smiled at me and told me to sit on the ground.
She had mastered anger with the tools she had found.
"I'm going to share. Some take practice, but they can be fun.
You must promise to try each and every one."

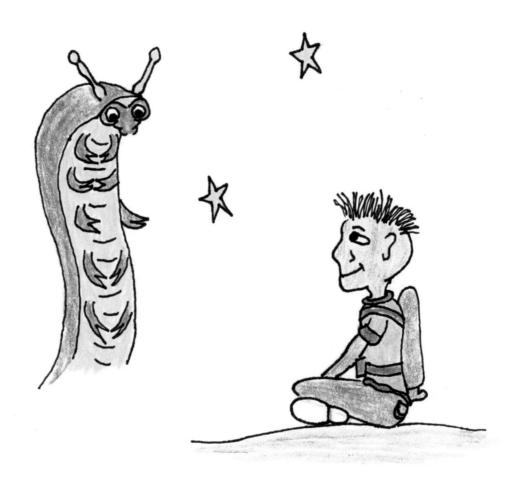

"On Mondays, I control my anger by talking to Ms. O'Toole.
She's a cool teacher who works down at the school.
I tell her what bugs me, and then she makes me laugh.
I work through that, then I finish my math."

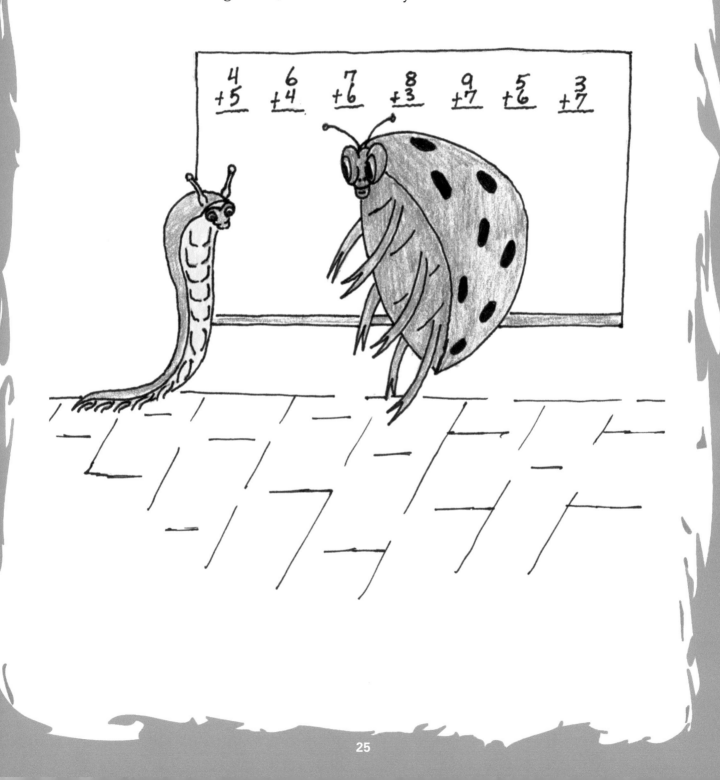

"On Tuesdays, I do exercise . . . pushups and the like.
Things don't seem to bother me on the treadmill or the bike.
I burn up some energy, and then I feel great.
Then, I talk things over with my best friend Kate."

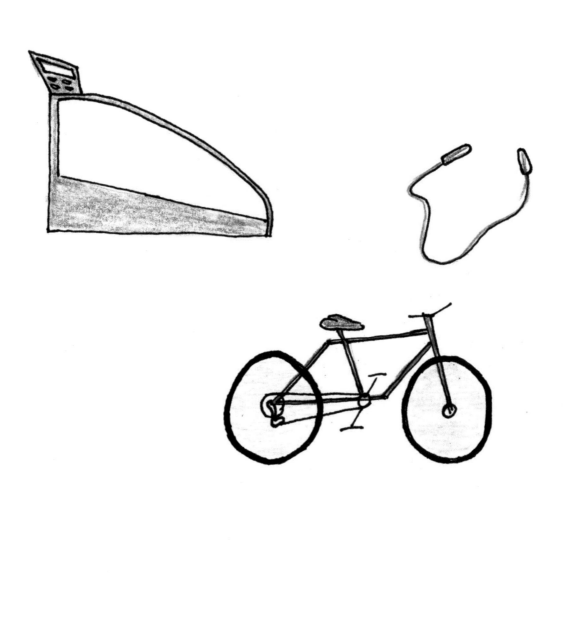

"On Wednesdays, I remember how important it is to breathe.
I become calm, and the stress seems to leave.
I breathe in deeply, all I can hold.
Then I breathe out slowly like I was told."

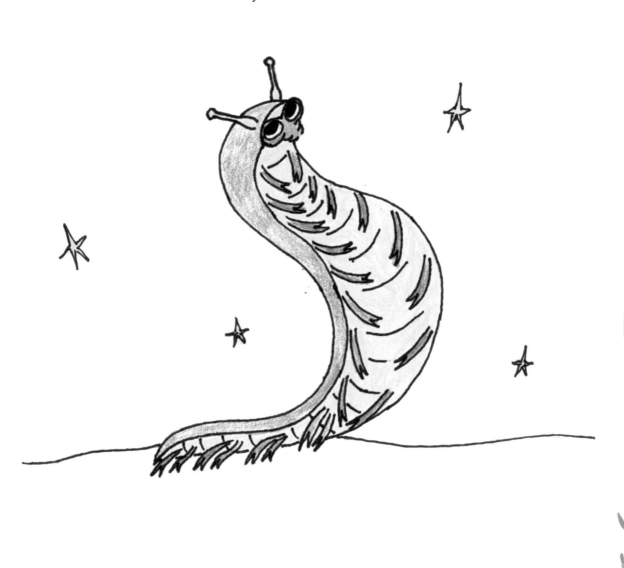

"Thursday's my favorite . . . I will draw, think and draw.
When things are bugging me, I make what I saw.
I describe every detail, every smile and frown.
After I'm done drawing, I no longer feel down."

"On Fridays, I write down all the feelings I have in my head –
the words of the argument, everything that was said.
I make a plan to control myself and follow every letter . . .
I won't blow my cool this time; this time I will do better."

Teased
Alone
Confused
Left out

Misunderstood
Ignored
Annoyed
Frustrated

"On Saturdays, I find a quiet place to relax without the noise –
15 minutes of cool down time without other girls and boys.
A good day is my choice; it's all up to me.
To see if my plan will work, I'll have to wait and see."

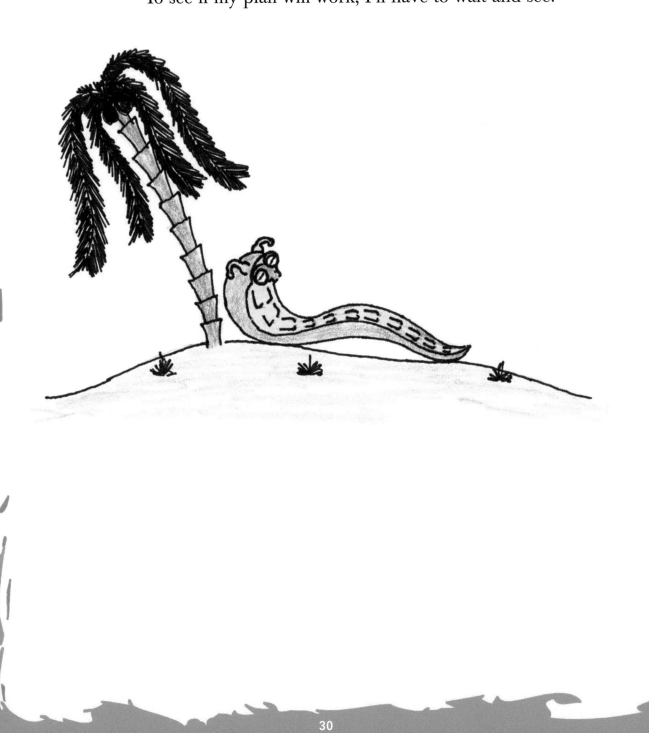

"On Sundays, I use everything to keep my cool,
but trying hard everyday is the Alien rule.
We all make mistakes, and that's not so bad.
We can always learn something from the troubles we've had."

Talk to Someone

Exercise

Use my Breathing

Drawing

JOURNALING

TIMEOUT/RELAXING

Thinking about what I could do better next time.

"Tex, you will cool your jets if you give it a shot.
It was nice meeting you. I like you a lot.
It's time for dinner. I must go to my place,
and it's time for you to blast into space."

"Maroy, Maroy where are you? I'm all alone.
Without you, I will never get home.
It's so dark and scary, I don't know what to do."
But soon Tex found the courage, and off he flew.

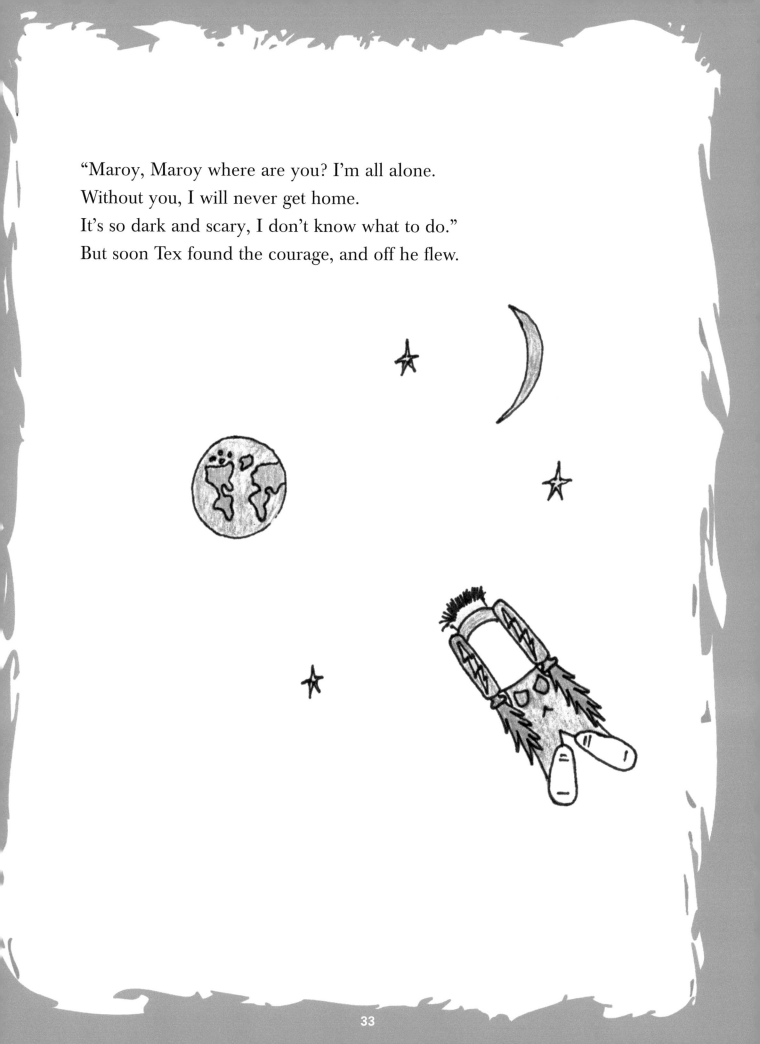

Tex maneuvered with ease . . . left, right, up and down . . . pretty soon in the distance he could see his hometown. Slowly, so gently, he landed softly in bed

"It's time to get up Tex . . . wake up sleepy head."

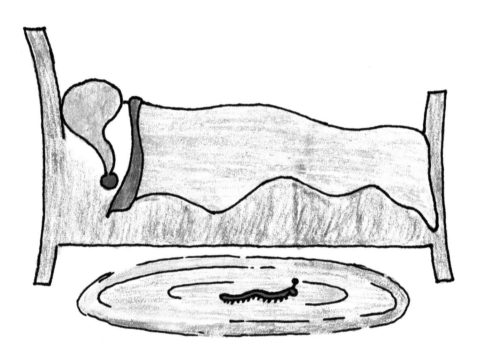

The End.

Manage
Anger
Relying
On
Yourself

Printed in the United States
By Bookmasters